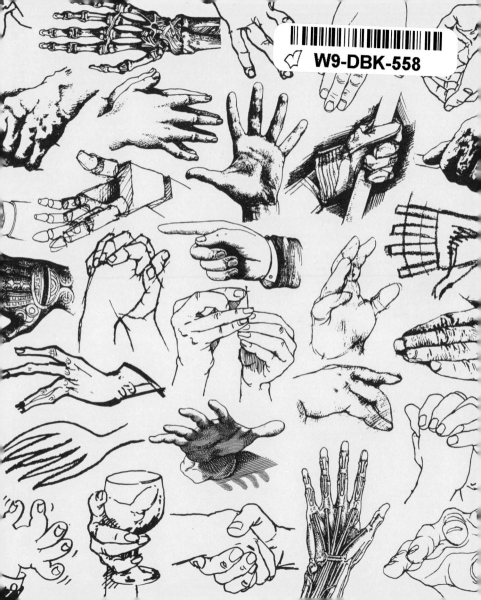

WAYS
OF
DRAWING
Hands

DAY AFTER DAY,
NEVER FAIL TO DRAW SOMETHING
WHICH, HOWEVER LITTLE IT MAY BE,
WILL YET IN THE END BE MUCH,
AND DO THY BEST.

CENNINO CENNINI C.1390

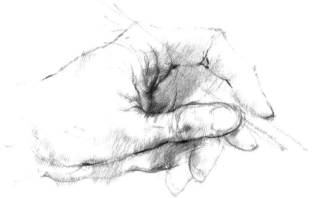

WAYS
OF
DRAWING

Hands

A guide to expanding your visual awareness

RUNNING PRESS
PHILADELPHIA, PENNSYLVANIA

**Produced, edited, and designed by Inklink,
Greenwich, London, England.**

Canadian representatives: General Publishing Co., Ltd.,
30 Lesmill Road, Don Mills, Ontario M3B 2T6.
International representatives: Worldwide Media Services, Inc.,
30, Montgomery Street, Jersey City, New Jersey 07302.

9 8 7 6 5 4 3 2 1
Digit on the right indicates the number of this printing.

Ways of Drawing Hands,
a guide to expanding
your visual awareness

**This edition first published
in the United States by
Running Press Book
Publishers.**

Library of Congress
Catalog Number
93-085535

ISBN 1-56138-393-7

**CONSULTANT ARTISTS AND EDITORIAL BOARD
Concept and general editor, Simon Jennings
Main contributing artists, Robin Harris and Victor Ambrus
Additional artwork, Albert Jackson
Anatomical artist, Michael Woods
Art education advisor, Carolynn Cooke
Design and art direction, Simon Jennings
Additional design work, Alan Marshall
Text editors, Ian Kearey and Albert Jackson
Historical research, Chris Perry**

Typeset in Akzidenz Grotesque and Univers by Inklink
Image generation by T. D. Studios, London
Printed by South Sea International Press, Hong Kong

This book may be ordered by mail from the publisher.
Please add $2.50 for postage and handling.
But try your bookstore first!

**Running Press Book Publishers
125 South Twenty-Second Street
Philadelphia, Pennsylvania 19103-4399**

CONTENTS

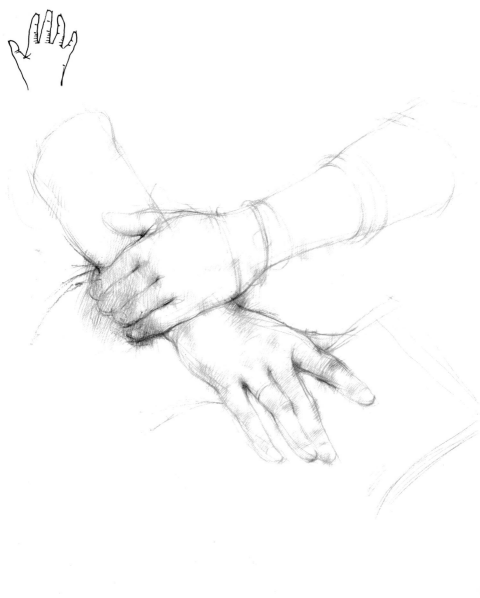

Introduction The urge to draw is common to all cultures. Young children first make exploratory marks and then move on to produce drawings with many meanings. As they grow up, many people lose that early unselfconsciousness in communicating visually. The ideas in this book form a framework to develop confidence in mark-making, and give you the inspiration to bridge the gap between the urge to draw and its fulfilment. In "**Anatomy**," you will see how the underlying, complex structure of the bones and sinews affects hands' form and movement. "**Seeing**" shows how, when carefully observed from life, the formal elements of proportion, shape, and texture contribute to the subtle messages that a drawing can convey about the owner of the hand. It is part of the excitement of drawing to understand the language of the world of art, and to collect together the drawing materials – sharp pencils, pens and inks, charcoal, conté crayons, paper. Familiarity with these different mediums is best gained through using them, and this book, with its "**Basic Essentials**" summary, will guide you through different ways of looking, to find the appropriate medium for your subject. The "**Index of Possibilities**" gives ideas for further exploration, showing that drawing is a universal mode of communication, linked to cultural traditions.

Remember, though, that the drawings in this book are not a formula for representation; rather, they encourage you to discover your own, personal response and way of communicating. The strongest elements of this response are your thoughts and actions; if they require you to struggle during the process of your drawing, the results will be all the more interesting and meaningful.

ANATOMY

Understanding anatomy Few artists require a detailed scientific knowledge of anatomy, but an appreciation of how the human hand is constructed will enable you to interpret what you see on the surface with greater accuracy. The hand is not simply a flat paddle adorned with a row of fingers. It is a complex matrix of bone, sinew, and muscle, operating within an elastic covering of skin. Understanding the relationship of those parts and their range of movement is integral to conveying the effects they have on the external contours of the hand; what you as an artist are trying to portray in two dimensions.

However, it is not slavish reproduction of correct anatomical detail that leads to successful drawing. From the fleshy hands of children and young women to the bony fingers and veined hands of old men,

each hand is unique and requires close observation before you can reproduce its precise character.

As a first step, get to know your own hands intimately by drawing them from different angles. Make sketches of their general proportions, then make detailed studies of your knuckle joints, the patterns of veins on the back of your hand, and the way the muscles bunch up as you close your fingers to make a fist. Try to imagine that those familiar hands belong to someone else so that you can be as objective as possible, and build up a visual repertoire. With practice, you will find that even a basic familiarity with your own anatomy will enable you to see beyond the superficial appearance of any hand and help you visualize and plan your drawings with greater confidence.

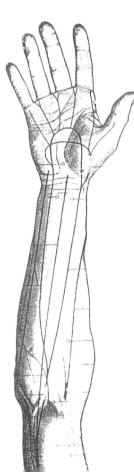

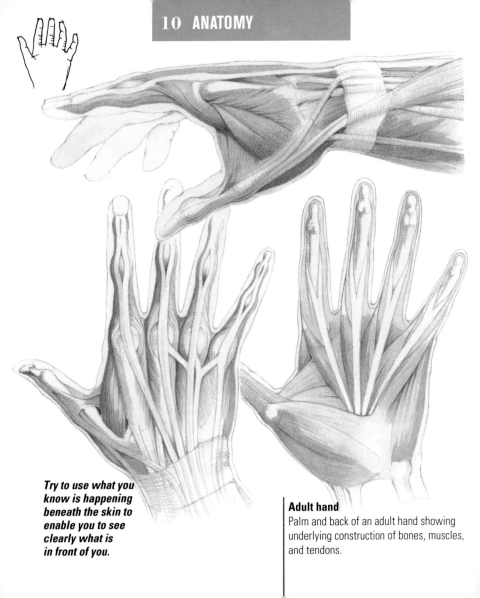

Try to use what you know is happening beneath the skin to enable you to see clearly what is in front of you.

Adult hand
Palm and back of an adult hand showing underlying construction of bones, muscles, and tendons.

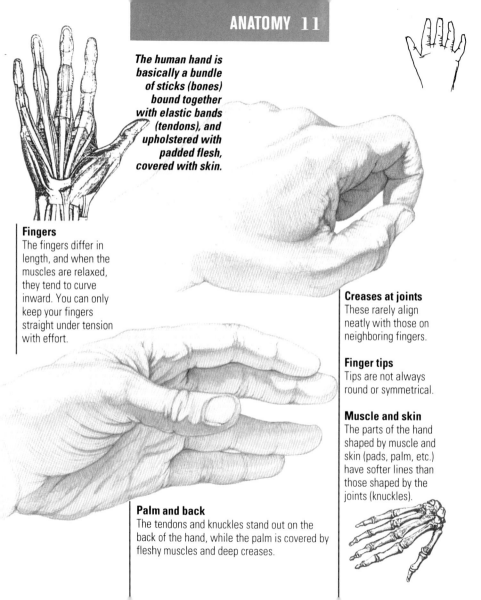

The human hand is basically a bundle of sticks (bones) bound together with elastic bands (tendons), and upholstered with padded flesh, covered with skin.

Fingers
The fingers differ in length, and when the muscles are relaxed, they tend to curve inward. You can only keep your fingers straight under tension with effort.

Creases at joints
These rarely align neatly with those on neighboring fingers.

Finger tips
Tips are not always round or symmetrical.

Muscle and skin
The parts of the hand shaped by muscle and skin (pads, palm, etc.) have softer lines than those shaped by the joints (knuckles).

Palm and back
The tendons and knuckles stand out on the back of the hand, while the palm is covered by fleshy muscles and deep creases.

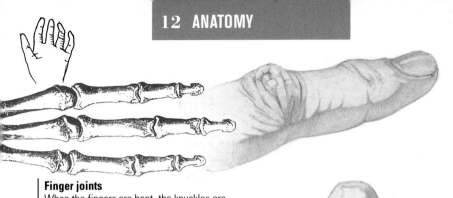

Finger joints
When the fingers are bent, the knuckles are sharply defined, but when you straighten your fingers, the slack skin over the joints is formed into deep folds and creases.

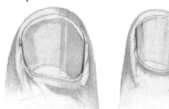

Fingernails
Look at one of your hands, and see how the fingernails vary in shape and size. This difference is even more pronounced from individual to individual, according to age, sex, and ethnic group. The sides of the nail may be straight, but the root and tip are invariably curved.

Back of the hand
The back of a closed hand is slightly convex and virtually featureless. However, an elderly hand may be rugged, with a few raised veins.

Opposable thumb
The fully-opposable thumb is unique to the human hand. As it moves towards the fingers, it creates deep creases across the large group of muscles at the base of the thumb.

Finger gaps
Soft pads line the individual bones. There are often noticeable gaps between slim fingers.

The palm
The palm is a shallow cup, formed by two large muscle groups and the joints at the base of the fingers. The depth of this cup is increased by flexing thumb and fingers, and large folds of skin trace well-defined lines.

SEEING

Learning to see We all imagine we are taking in what we see around us, but when asked to recall details, the average person is notoriously unreliable. We need to train ourselves to look closely, to really see an object, a person, a landscape, before we can translate that image into a meaningful drawing.

Surprisingly, even some skillful figure artists claim to have difficulty drawing hands. Perhaps to these artists, hands are almost an afterthought, mere details that do not command the attention given to drawing a portrait. In fact, hands provide a great deal of subliminal information. Simple gestures can convey messages we all understand, part of a universal body language we use to communicate with each other on a level that is more direct and subtle than clumsy, spoken languages.

Drawing from reference material such as photographs, it is possible to convey something of the overall shape and proportions of human hands, but there is no substitute for working from life if you want to capture the three-dimensional solidity of a hand. Once you learn to observe a hand with an artist's eye, you will begin to almost feel its contours and textures with your pen or pencil. The concentration involved in this process becomes so intense that the drawing itself develops into an almost unconscious act, forming itself on the paper.

The trick is to forget you are making a drawing – a work of art – and to let the creative act become the object of the exercise, rather than the finished product. You will be surprised how your drawing skills improve.

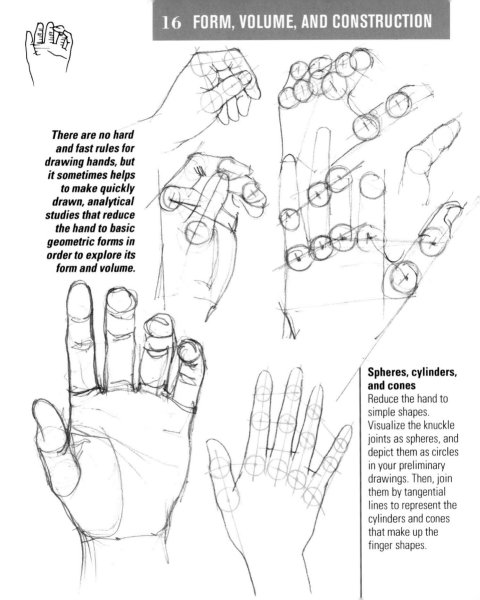

There are no hard and fast rules for drawing hands, but it sometimes helps to make quickly drawn, analytical studies that reduce the hand to basic geometric forms in order to explore its form and volume.

Spheres, cylinders, and cones

Reduce the hand to simple shapes. Visualize the knuckle joints as spheres, and depict them as circles in your preliminary drawings. Then, join them by tangential lines to represent the cylinders and cones that make up the finger shapes.

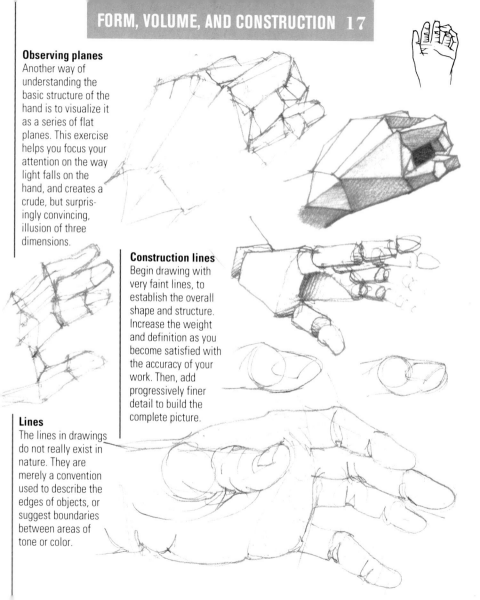

Observing planes
Another way of understanding the basic structure of the hand is to visualize it as a series of flat planes. This exercise helps you focus your attention on the way light falls on the hand, and creates a crude, but surprisingly convincing, illusion of three dimensions.

Construction lines
Begin drawing with very faint lines, to establish the overall shape and structure. Increase the weight and definition as you become satisfied with the accuracy of your work. Then, add progressively finer detail to build the complete picture.

Lines
The lines in drawings do not really exist in nature. They are merely a convention used to describe the edges of objects, or suggest boundaries between areas of tone or color.

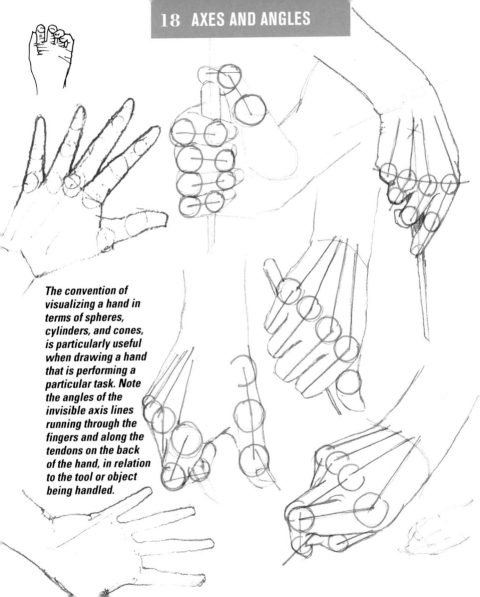

The convention of visualizing a hand in terms of spheres, cylinders, and cones, is particularly useful when drawing a hand that is performing a particular task. Note the angles of the invisible axis lines running through the fingers and along the tendons on the back of the hand, in relation to the tool or object being handled.

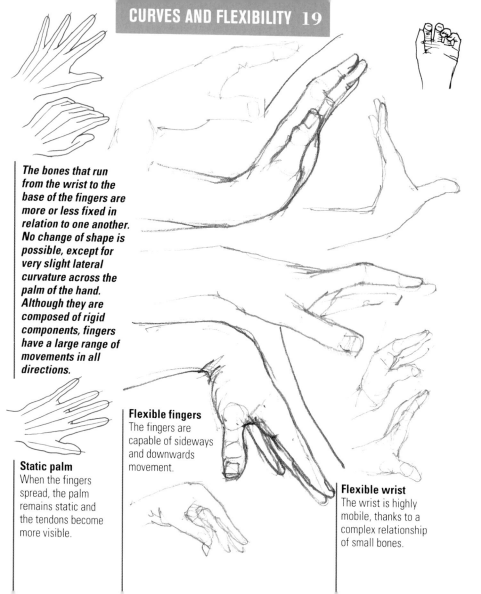

The bones that run from the wrist to the base of the fingers are more or less fixed in relation to one another. No change of shape is possible, except for very slight lateral curvature across the palm of the hand. Although they are composed of rigid components, fingers have a large range of movements in all directions.

Static palm
When the fingers spread, the palm remains static and the tendons become more visible.

Flexible fingers
The fingers are capable of sideways and downwards movement.

Flexible wrist
The wrist is highly mobile, thanks to a complex relationship of small bones.

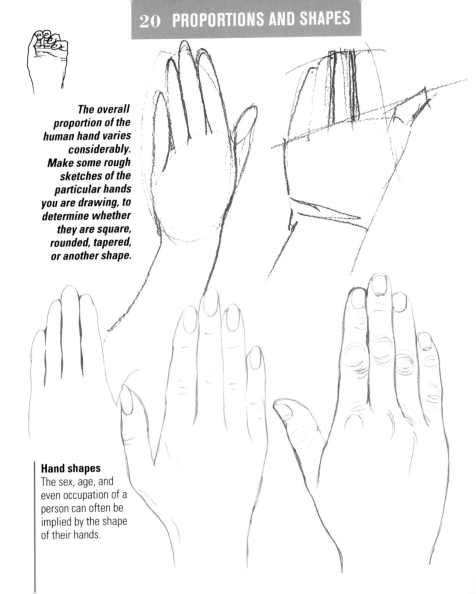

The overall proportion of the human hand varies considerably. Make some rough sketches of the particular hands you are drawing, to determine whether they are square, rounded, tapered, or another shape.

Hand shapes
The sex, age, and even occupation of a person can often be implied by the shape of their hands.

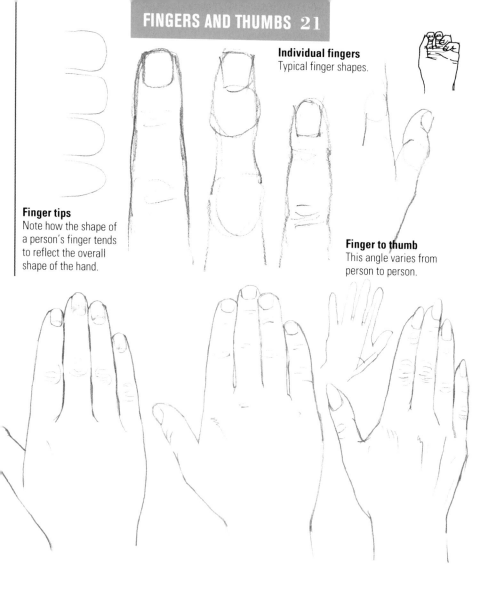

Individual fingers
Typical finger shapes.

Finger tips
Note how the shape of a person's finger tends to reflect the overall shape of the hand.

Finger to thumb
This angle varies from person to person.

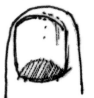

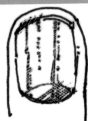

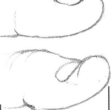

Despite their small size, fingernails provide us with a wealth of information, and impart character to studies of the hand.

Bulging finger tips
True-to-life drawings will include such details as the fleshy finger tips of a nervous person who habitually chews his/her nails.

Ridges and flaws
When making studies of older hands, you will notice that the nails are often textured. They will exhibit distinct, vertical ridges.

Close-up studies
Close scrutiny of the fingernails can reveal something about a person's occupation. Clean, manicured nails suggest a life of comparative leisure, while broken, discolored nails are more likely to belong to a laborer. Don't forget the cuticle.

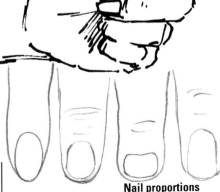

Closed female hand
A quick sketch (left), where character and gender are implied by the fingernails.

Nail shapes
Typical fingernail shapes are square, round, and elliptical.

Nail proportions
Make some quick studies to discover for yourself the wide variety of proportions. There is clearly no such thing as the standard fingernail.

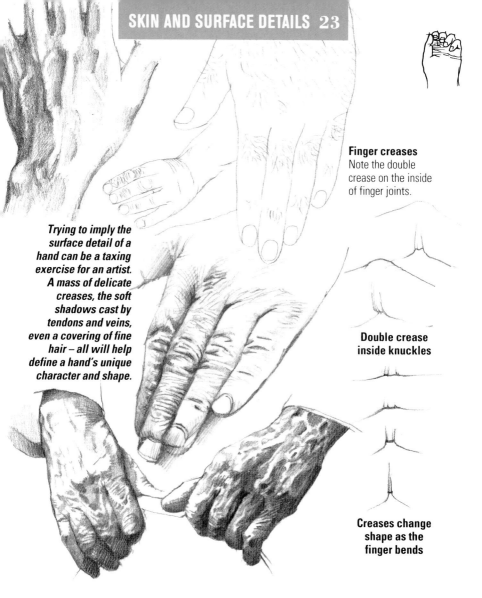

Trying to imply the surface detail of a hand can be a taxing exercise for an artist. A mass of delicate creases, the soft shadows cast by tendons and veins, even a covering of fine hair – all will help define a hand's unique character and shape.

Finger creases
Note the double crease on the inside of finger joints.

Double crease inside knuckles

Creases change shape as the finger bends

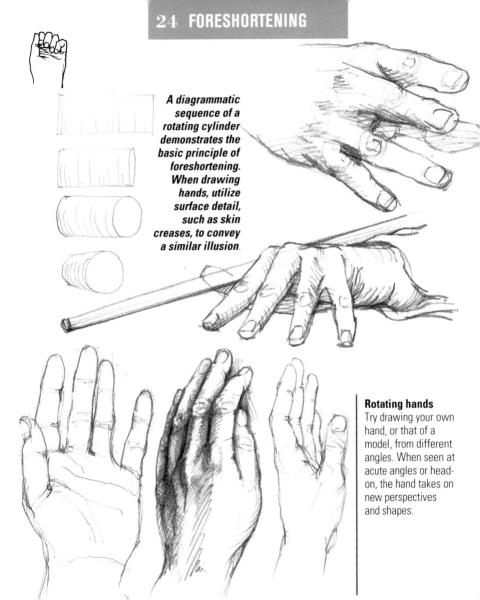

A diagrammatic sequence of a rotating cylinder demonstrates the basic principle of foreshortening. When drawing hands, utilize surface detail, such as skin creases, to convey a similar illusion.

Rotating hands

Try drawing your own hand, or that of a model, from different angles. When seen at acute angles or head-on, the hand takes on new perspectives and shapes.

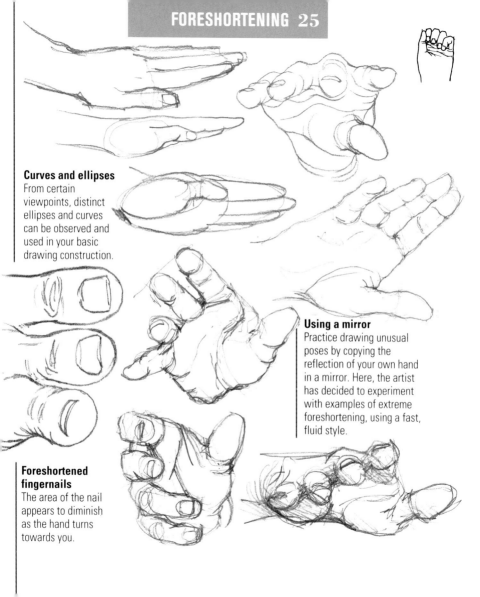

Curves and ellipses
From certain viewpoints, distinct ellipses and curves can be observed and used in your basic drawing construction.

Using a mirror
Practice drawing unusual poses by copying the reflection of your own hand in a mirror. Here, the artist has decided to experiment with examples of extreme foreshortening, using a fast, fluid style.

Foreshortened fingernails
The area of the nail appears to diminish as the hand turns towards you.

When it comes to drawing and studying the human hand, there is no shortage of easily available visual references. Most artists prefer to use live models, but it can sometimes be more convenient to use photographs, especially when attempting to capture sequences of action.

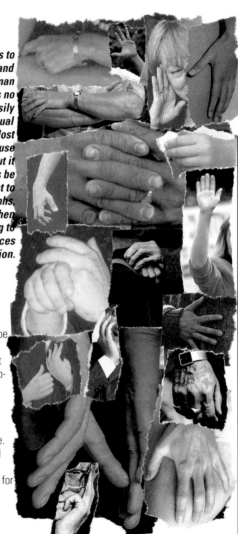

Advantages of photography

Photography may be your only realistic alternative for that particularly hard-to-find pose. It can freeze a fleeting movement into a ready-made two-dimensional image. Many professional illustrators use "instant" cameras for quick results.

Tracing photographs

Tracing from a photograph may seem like an easy way to make a drawing, but it does not necessarily lead to an accurate representation. Although it may be entirely convincing as a printed photograph, the same image may look distorted when reduced to a drawn outline. This is most often the result of lens distortion, that artificially stretches or foreshortens an object in camera. As a result, when using photographs for reference, you must be willing to make alterations to achieve correct proportions.

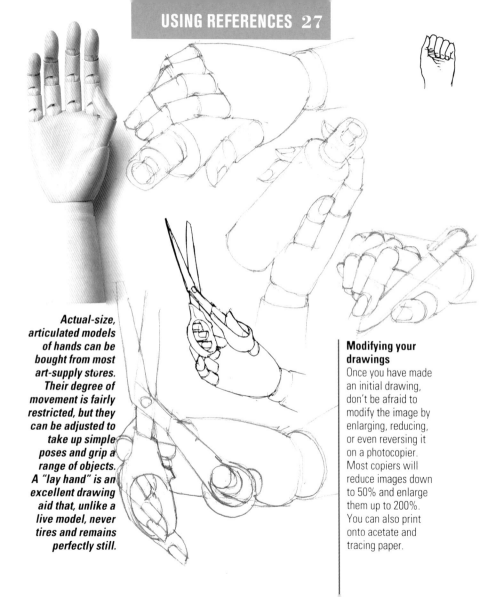

Actual-size, articulated models of hands can be bought from most art-supply stores. Their degree of movement is fairly restricted, but they can be adjusted to take up simple poses and grip a range of objects. A "lay hand" is an excellent drawing aid that, unlike a live model, never tires and remains perfectly still.

Modifying your drawings

Once you have made an initial drawing, don't be afraid to modify the image by enlarging, reducing, or even reversing it on a photocopier. Most copiers will reduce images down to 50% and enlarge them up to 200%. You can also print onto acetate and tracing paper.

Whether you are using a model or drawing your own hand, it pays to make the pose as comfortable as possible. A relaxed pose avoids fatigue, and also reduces pressure on the artist to work quickly. Try supporting the arm and hand with cushions or books.

Relaxed hand
A relaxed hand tends to fall automatically into a semi-closed position, with the thumb lying across the palm and the fingers gently folded around each other.

Pen-and-ink studies (right) of a relaxed hand

Sleeping hand
Here the model (left) is asleep, and the hand falls naturally into a restful pose. In this pencil study, the volume and form of the hand is conveyed with a build-up of tone within a sketched outline.

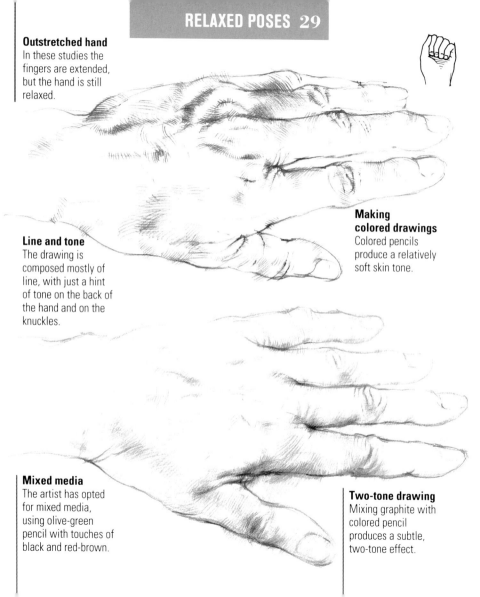

Outstretched hand
In these studies the fingers are extended, but the hand is still relaxed.

Line and tone
The drawing is composed mostly of line, with just a hint of tone on the back of the hand and on the knuckles.

Making colored drawings
Colored pencils produce a relatively soft skin tone.

Mixed media
The artist has opted for mixed media, using olive-green pencil with touches of black and red-brown.

Two-tone drawing
Mixing graphite with colored pencil produces a subtle, two-tone effect.

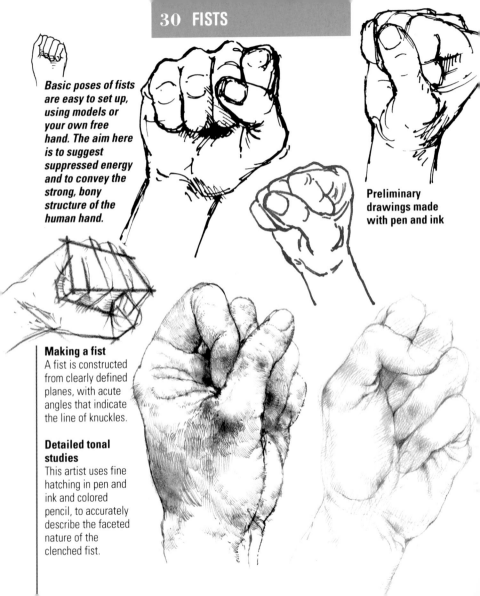

Basic poses of fists are easy to set up, using models or your own free hand. The aim here is to suggest suppressed energy and to convey the strong, bony structure of the human hand.

Preliminary drawings made with pen and ink

Making a fist
A fist is constructed from clearly defined planes, with acute angles that indicate the line of knuckles.

Detailed tonal studies
This artist uses fine hatching in pen and ink and colored pencil, to accurately describe the faceted nature of the clenched fist.

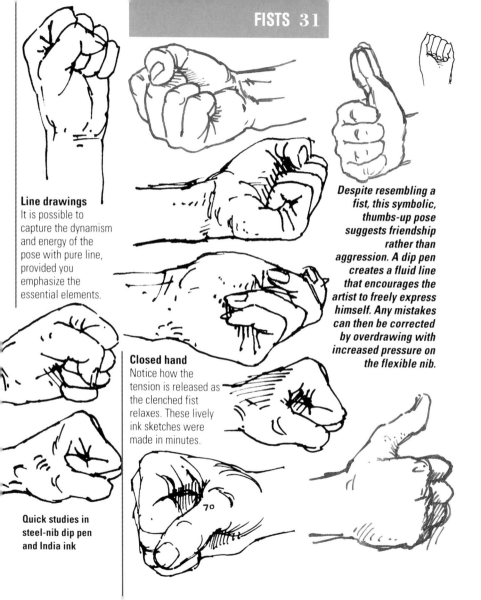

Line drawings
It is possible to capture the dynamism and energy of the pose with pure line, provided you emphasize the essential elements.

Despite resembling a fist, this symbolic, thumbs-up pose suggests friendship rather than aggression. A dip pen creates a fluid line that encourages the artist to freely express himself. Any mistakes can then be corrected by overdrawing with increased pressure on the flexible nib.

Closed hand
Notice how the tension is released as the clenched fist relaxes. These lively ink sketches were made in minutes.

Quick studies in steel-nib dip pen and India ink

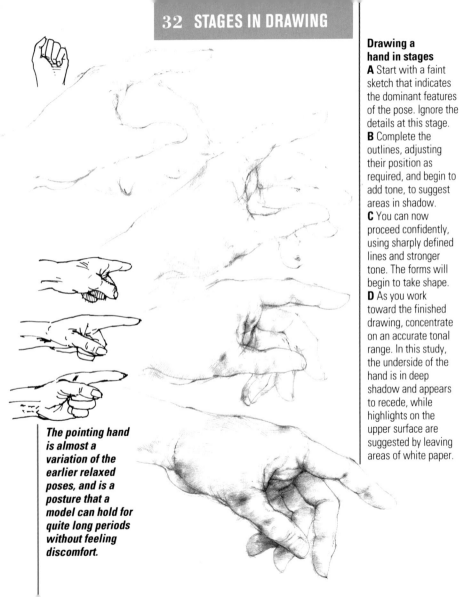

Drawing a hand in stages

A Start with a faint sketch that indicates the dominant features of the pose. Ignore the details at this stage.
B Complete the outlines, adjusting their position as required, and begin to add tone, to suggest areas in shadow.
C You can now proceed confidently, using sharply defined lines and stronger tone. The forms will begin to take shape.
D As you work toward the finished drawing, concentrate on an accurate tonal range. In this study, the underside of the hand is in deep shadow and appears to recede, while highlights on the upper surface are suggested by leaving areas of white paper.

The pointing hand is almost a variation of the earlier relaxed poses, and is a posture that a model can hold for quite long periods without feeling discomfort.

The converse of the clenched fist is the outstretched hand, with its taut tendons and tense muscles. This is not a pose you can expect a model to hold for long periods. Either make preliminary sketches, from which you can make finished drawings, or work from photographs.

Male hand at full stretch

Female hand at full stretch
A typical female hand tends to be slimmer than its male counterpart, with comparatively long, tapering fingers. The fingernails are often prominent features.

Clawing hand
A poised, defensive pose (right), with every sinew at full stretch.

Wrist bone
Note also the distinctive bony wrist that creates a characteristic arch when seen from certain angles.

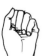

In order to capture the sometimes fleeting movement of hands in action, it pays to develop the knack of putting down what you see with a fast, economical style. These drawings show variations on a common theme: the gripping hand.

Relaxed grip

When a hand holds a staff or pole upright, it appears perfectly relaxed, with the muscles used almost at rest.

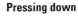

Pressing down

When pressing clothes, the inside of the finger and the soft pad of the thumb are flattened against the handle of the iron. The muscle between the thumb and index finger swells with the pressure used.

Thumb pressure

When gripping a narrow object, the thumb is used to counterbalance the action of the fingers. This action is used for peeling potatoes or whittling wood.

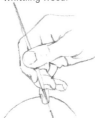

Pay particular attention to the relationship of the fingers as the hand grips objects of different diameter; and note how the hand displays degrees of tension and pressure, depending on what it is doing.

Fingers together

The fingers of this hand (left) are squeezed together by the effort of gripping an object that is too large for it to encircle. The only way it can exercise control here is by employing the friction between the skin and the surface of the object held.

Exerting control

When operating a lever, the fingers exert control, rather than grip the object firmly. Observe the exaggerated angle of the wrist in this position.

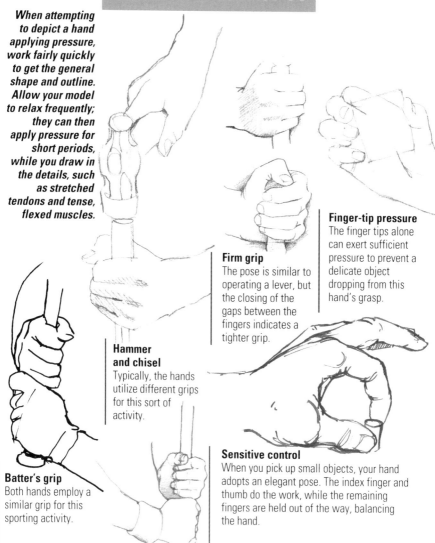

When attempting to depict a hand applying pressure, work fairly quickly to get the general shape and outline. Allow your model to relax frequently; they can then apply pressure for short periods, while you draw in the details, such as stretched tendons and tense, flexed muscles.

Finger-tip pressure
The finger tips alone can exert sufficient pressure to prevent a delicate object dropping from this hand's grasp.

Firm grip
The pose is similar to operating a lever, but the closing of the gaps between the fingers indicates a tighter grip.

Hammer and chisel
Typically, the hands utilize different grips for this sort of activity.

Batter's grip
Both hands employ a similar grip for this sporting activity.

Sensitive control
When you pick up small objects, your hand adopts an elegant pose. The index finger and thumb do the work, while the remaining fingers are held out of the way, balancing the hand.

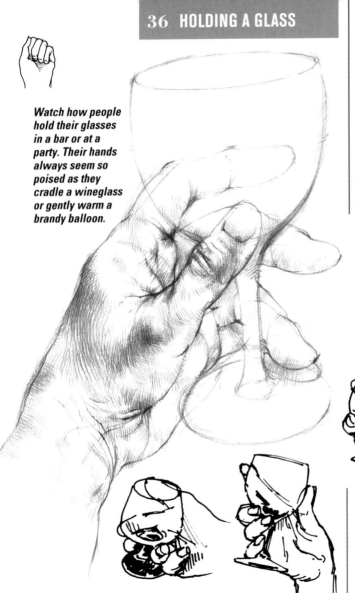

Watch how people hold their glasses in a bar or at a party. Their hands always seem so poised as they cradle a wineglass or gently warm a brandy balloon.

Holding a wineglass

In this exquisite pencil study (left), depth is suggested by the use of strong hatching in the foreground. The fingers behind the glass are merely hinted at with fine linework.

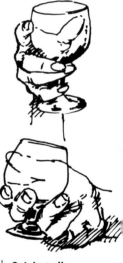

Quick studies

A fiber-tip pen on smooth paper was used for these preliminary studies.

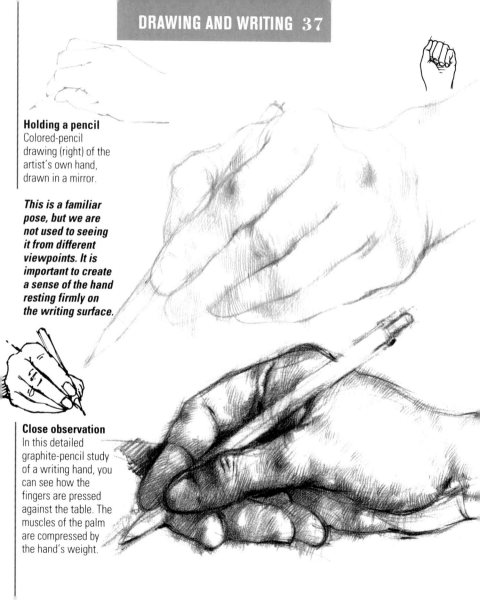

Holding a pencil
Colored-pencil drawing (right) of the artist's own hand, drawn in a mirror.

This is a familiar pose, but we are not used to seeing it from different viewpoints. It is important to create a sense of the hand resting firmly on the writing surface.

Close observation
In this detailed graphite-pencil study of a writing hand, you can see how the fingers are pressed against the table. The muscles of the palm are compressed by the hand's weight.

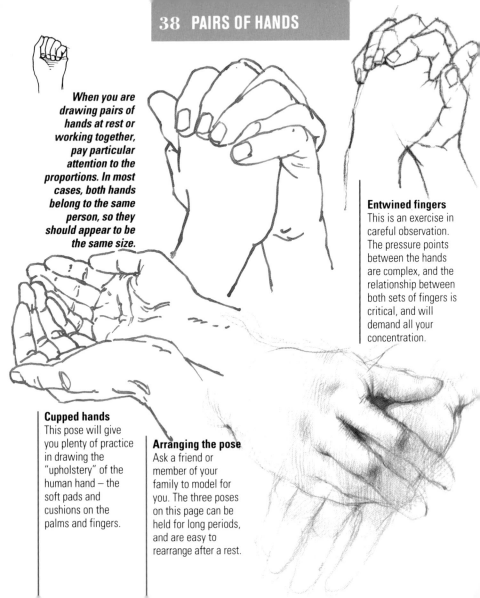

When you are drawing pairs of hands at rest or working together, pay particular attention to the proportions. In most cases, both hands belong to the same person, so they should appear to be the same size.

Entwined fingers
This is an exercise in careful observation. The pressure points between the hands are complex, and the relationship between both sets of fingers is critical, and will demand all your concentration.

Cupped hands
This pose will give you plenty of practice in drawing the "upholstery" of the human hand – the soft pads and cushions on the palms and fingers.

Arranging the pose
Ask a friend or member of your family to model for you. The three poses on this page can be held for long periods, and are easy to rearrange after a rest.

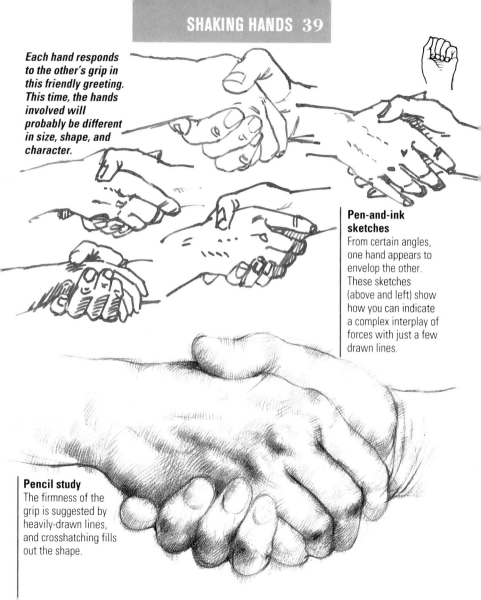

Each hand responds to the other's grip in this friendly greeting. This time, the hands involved will probably be different in size, shape, and character.

Pen-and-ink sketches
From certain angles, one hand appears to envelop the other. These sketches (above and left) show how you can indicate a complex interplay of forces with just a few drawn lines.

Pencil study
The firmness of the grip is suggested by heavily-drawn lines, and crosshatching fills out the shape.

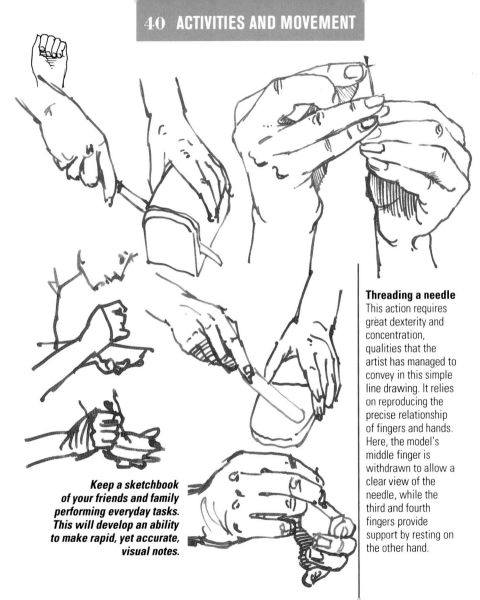

Threading a needle
This action requires great dexterity and concentration, qualities that the artist has managed to convey in this simple line drawing. It relies on reproducing the precise relationship of fingers and hands. Here, the model's middle finger is withdrawn to allow a clear view of the needle, while the third and fourth fingers provide support by resting on the other hand.

Keep a sketchbook of your friends and family performing everyday tasks. This will develop an ability to make rapid, yet accurate, visual notes.

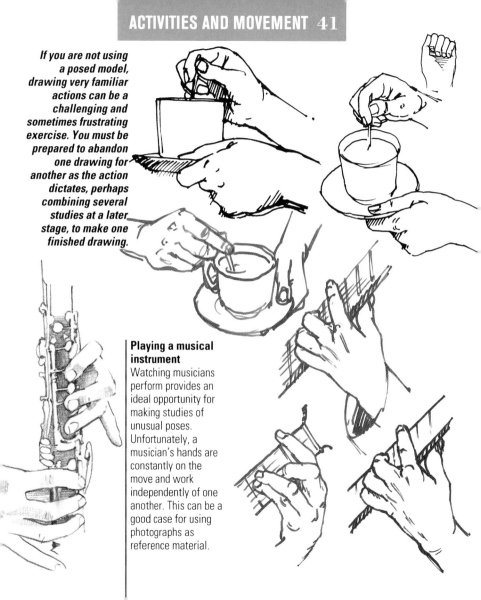

If you are not using a posed model, drawing very familiar actions can be a challenging and sometimes frustrating exercise. You must be prepared to abandon one drawing for another as the action dictates, perhaps combining several studies at a later stage, to make one finished drawing.

Playing a musical instrument

Watching musicians perform provides an ideal opportunity for making studies of unusual poses. Unfortunately, a musician's hands are constantly on the move and work independently of one another. This can be a good case for using photographs as reference material.

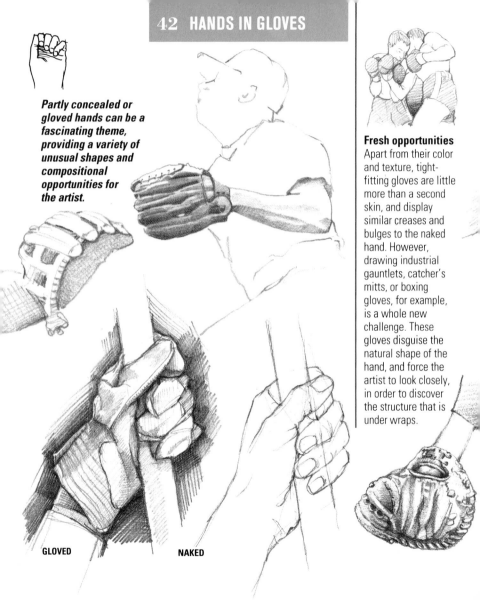

Partly concealed or gloved hands can be a fascinating theme, providing a variety of unusual shapes and compositional opportunities for the artist.

Fresh opportunities
Apart from their color and texture, tight-fitting gloves are little more than a second skin, and display similar creases and bulges to the naked hand. However, drawing industrial gauntlets, catcher's mitts, or boxing gloves, for example, is a whole new challenge. These gloves disguise the natural shape of the hand, and force the artist to look closely, in order to discover the structure that is under wraps.

GLOVED

NAKED

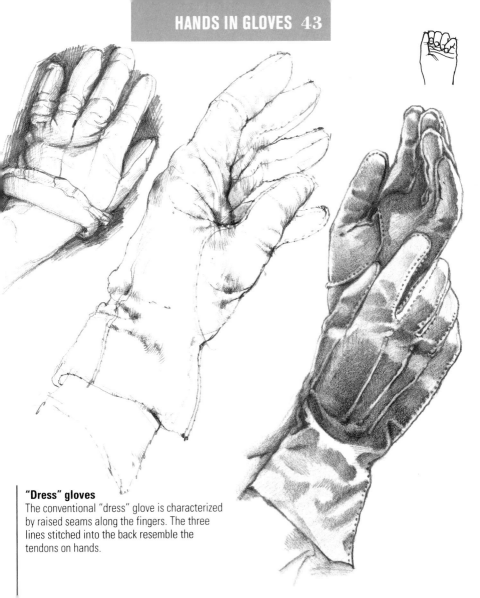

"Dress" gloves
The conventional "dress" glove is characterized by raised seams along the fingers. The three lines stitched into the back resemble the tendons on hands.

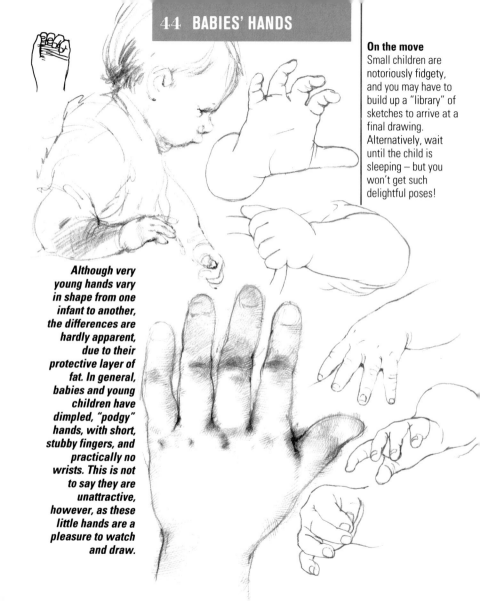

On the move

Small children are notoriously fidgety, and you may have to build up a "library" of sketches to arrive at a final drawing. Alternatively, wait until the child is sleeping – but you won't get such delightful poses!

Although very young hands vary in shape from one infant to another, the differences are hardly apparent, due to their protective layer of fat. In general, babies and young children have dimpled, "podgy" hands, with short, stubby fingers, and practically no wrists. This is not to say they are unattractive, however, as these little hands are a pleasure to watch and draw.

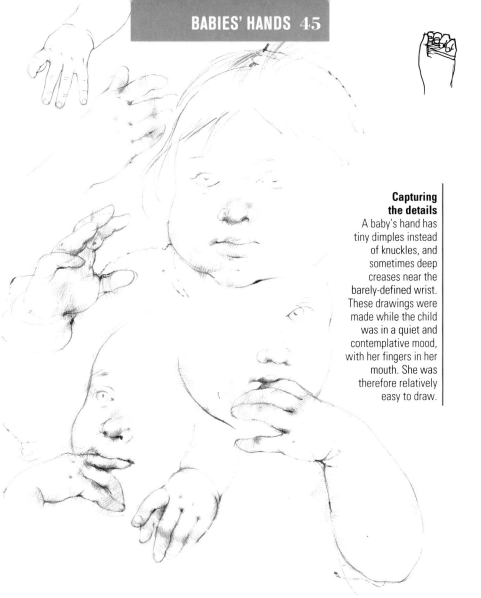

Capturing the details

A baby's hand has tiny dimples instead of knuckles, and sometimes deep creases near the barely-defined wrist. These drawings were made while the child was in a quiet and contemplative mood, with her fingers in her mouth. She was therefore relatively easy to draw.

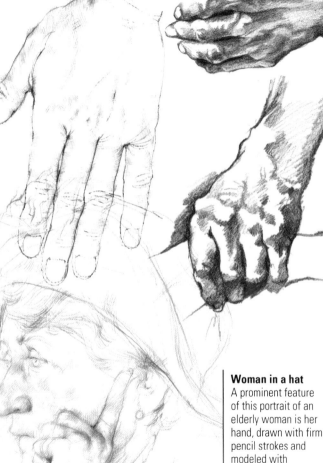

A pair of older hands will tell you much about a person – whether they have had to struggle to make a living, or have maybe led a protected life. Some hands will have grown older unmarked, while others are gnarled and twisted by wear and ill health.

Bringing out the character
Folds, creases, and veins are much more prominent in older hands; use these features to bring out the personality of the hands, and from that, the person.

Woman in a hat
A prominent feature of this portrait of an elderly woman is her hand, drawn with firm pencil strokes and modeled with delicate hatching.

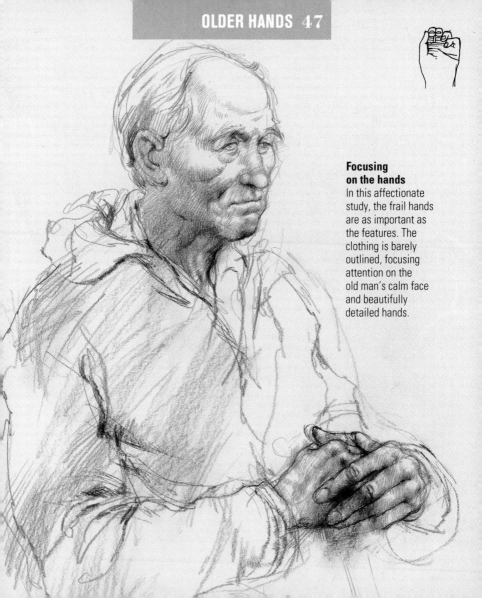

**Focusing
on the hands**
In this affectionate
study, the frail hands
are as important as
the features. The
clothing is barely
outlined, focusing
attention on the
old man's calm face
and beautifully
detailed hands.

Many artists fail to make the best use of a person's hands when planning a portrait. Instead of concentrating solely on the features, arrange the pose to include one or both hands, to suggest a particular mood, or just to add interest.

Hand supporting chin
In this portrait (left), the mood is conveyed by the hand alone. We are aware that the model's attention is sharply focused, even though the face is a mere suggestion.

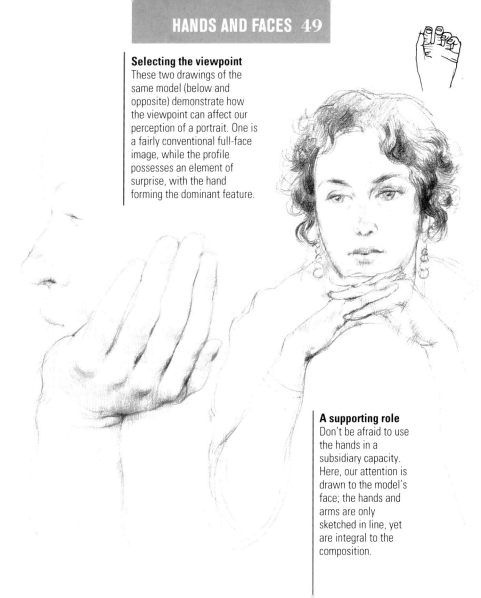

Selecting the viewpoint

These two drawings of the same model (below and opposite) demonstrate how the viewpoint can affect our perception of a portrait. One is a fairly conventional full-face image, while the profile possesses an element of surprise, with the hand forming the dominant feature.

A supporting role

Don't be afraid to use the hands in a subsidiary capacity. Here, our attention is drawn to the model's face; the hands and arms are only sketched in line, yet are integral to the composition.

BASIC ESSENTIALS

The only essential equipment you need for drawing is a pencil and a piece of paper. But, as your experience grows and your skills develop, you will hopefully discover your own drawing style. As this happens, you will probably develop a preference for using particular art materials. The visual information in this book is the work of several hands, and you will have seen references to a variety of art terms, materials, and techniques, some of which may be new to you. The following is a glossary of useful information that relates to the artwork featured in this book.

MATERIALS

Graphite pencil

The common, "lead" pencil, available in a variety of qualities and price ranges. The graphite core (lead) is encased in wood and graded, from softness to hardness: 9B is very, very soft, and 9H is very, very hard. HB is the middle-grade, everyday, writing pencil. The H-graded pencils are mostly used for technical work. For freehand drawing work, start around the 2B mark.

Colored pencil

A generic term for all pencils with a colored core. There is an enormous variety of colors and qualities available. They also vary in softness and hardness, but, unlike graphite pencils, this is seldom indicated on the packet.

Watercolor pencil

As above, except water-soluble and capable of creating a variety of "painterly" effects, by either wetting the tip of the pencil or working on dampened paper.

Conté crayon

Often known as conté pencil, and available in pencil or chalk-stick form. Originally a proprietary name that has become a generic term for a synthetic chalk-like medium, akin to a soft pastel or refined charcoal. It is available in black, red, brown, and white, but is best known in its red form. A traditional and well-loved drawing medium.

Steel-nib (dip) pen

The old-fashioned, dip-in-the-inkwell pen, a worthy and versatile drawing instrument. You will need to experiment with nibs for thickness and flexibility. They can take a while to break in and become free-flowing in use. However, the same

nib can give a variety of line widths and possibilities, as the artist changes the pressure on the pen.

Fiber-tip pen
Available in a variety of tip thicknesses. The ink flows smoothly, and fiber-tips make good drawing pens. When the ink runs out, they are useful for creating drybrush effects (see below).

Drawing ink
There are a variety of inks available, from water-soluble, writing (fountain pen or calligraphy) inks to thick, permanent, and waterproof drawing inks. India ink is a traditional drawing ink; it is waterproof, very dense, and dries with an interesting, shiny surface when used thickly. Drawing inks are also available in a range of colors, and can be thinned down with water for washes and applied with a brush.

Paper
Varies enormously in type, quality, texture, manufacture, and price. Paper is graded from smooth to rough, and is either smooth (hot-pressed, or HP), medium (cold-pressed, or CP), or rough. The comparative smoothness or roughness of a paper is known as the "tooth." For example, the tooth of a watercolor paper is generally more marked, and rougher than that of a cartridge paper for drawing. The tooth of a paper will influence the way that a medium reacts to it.

TERMS

Drybrush
A drawing effect created by using a sparsely-loaded brush, often with watercolor, or dry, fiber-tip pen. Drybrush allows the texture of the paper or any drawing beneath to show through.

Mixed media
A drawing made using a combination of two or more materials, for example, graphite pencil used with watercolor pencil.

Line drawing
A drawing made up purely of lines, with no attempt to indicate shadow or darker areas through shading or hatching.

Shading
An indication of shadow or dark areas in a drawing, made by darkening the overall surface of the area, often by rubbing or by hatching (see below).

Tone
The prevailing shade in a drawing, and its comparative dullness or brightness.

Highlight
The lightest point in a drawing. This is often the point where light strikes an object, such as a reflection in an eye, or on a surface.

Hatching
An illusion of shadow, tone, or texture, indicated by drawn lines.

Crosshatching
An illusion of darker shadows, tones, or textures, indicated by overlayering hatched lines at differing angles to each other.

Parallel hatching
Shadows, tones, or textures, indicated by drawing lines next to one another.

Scratching back
Removing the surface of a drawing with a sharp point, to reveal the paper, drawing, or color beneath. This will either lighten the drawing or create an interesting texture.

Lay hand/figure
An actual-size, wooden model of the human hand, or a scale model (about one-twelfth scale) of the human figure, useful for practice.

To indicate mass and volume, try hatching (drawing a series of lines), following the surface contours of the hand.

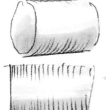

Crosshatching

Soft hatching
A subtle combination of parallel hatching and crosshatching in a pencil drawing.

Hatching following surface contours

Hatching
Imagine that the surface of the hand is covered by a fine grid of parallel lines. When foreshortened, these lines will appear as ellipses, converging at the edge of the image. This produces a progressive darkening that resembles shadow.

Hatching contrasts with white-paper highlights

More intense hatching creates darker tone

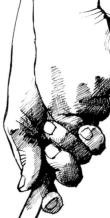

Mixed hatching
This drawing of a golfer's grip uses parallel hatching and crosshatching to suggest form.

This technique, known as "scratching back" (top right), is used by professional illustrators. It works best with ink on a smooth, hard surface such as plastic draft film or tracing paper.

A First, draw in the surface detail quite crudely.
B Then, scratch back into the bold drawing with a sharp knife, using hatching to reduce the strength of the line and model the detail. Similarly, use the point of the knife to reduce the thickness of line, to suggest areas under pressure.

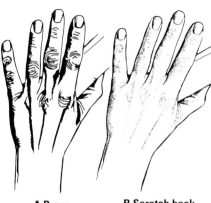

A Draw **B Scratch back**

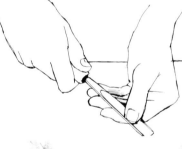

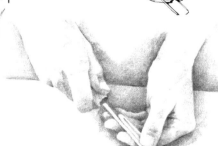

Varying the technique
The three studies (below) illustrate the effect of different techniques on the same subject.

1 Line only
Drawn lines denote the edges of three-dimensional objects or mark the junctions between areas of different tone or color.

2 Line and tone
Tone enables you to better infer solidity. Using pencil, the artist has begun to work up the background to help define the highly illuminated areas of the left hand.

3 Tone only
Surface modeling on the hands, the glint of steel, and the surface of the workbench have all been suggested entirely through the subtle application of tone.

POSSIBILITIES

Index of possibilities There are many ways of looking at the world, and there are as many ways of interpreting it. Art and creativity in drawing are not just about "correctness" or only working in a narrow, prescribed manner; they are about the infinite ways of seeing a three-dimensional object and setting it down.

In the earlier sections of this book, the consultant artists demonstrated the different approaches to drawing a specific subject. Their examples show how each has developed a personal way of seeing and setting down hands.

The following section of images is intended to further help you discover and develop your own creativity. It is an index of possibilities: an indication of just some of the inventive and inspirational directions that creative artists have taken,

and continue to take. This visual glossary demonstrates how the same subject can be treated in a variety of ways, and how different cultures and artistic conventions can affect treatments.

In every culture and age, symbols and simplified images are vital factors in communication. The earliest cave drawings reduce the forms of men and animals to the basics, and tell an immediate story; similarly, modern advertising campaigns and computer-based, corporate trademarks depend on our instant recognition of simplified forms. The graphic images in this section show how the artist's eye and hand can produce universally understood forms in all human societies.

A major part of artistic and technical development is being aware of, and open to, possibilities from outside your chosen sphere. To that end, the images in this section use a wide variety of materials and techniques. They may not all be pure "drawing," but each one expands the boundaries of what is possible, and provides new ways of seeing and interpreting hands.

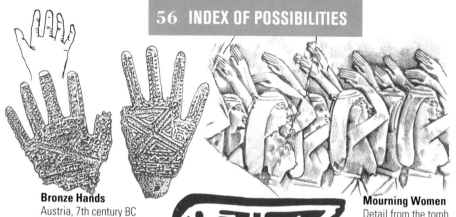

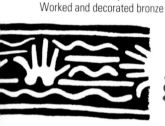

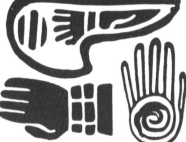

Bronze Hands
Austria, 7th century BC
Worked and decorated bronze

Mourning Women
Detail from the tomb
of Nespekashuti
Egypt, c. 610 BC
Carved limestone

Hand Motifs
Flat stamps
Mexico, 9th century
Paint and clay

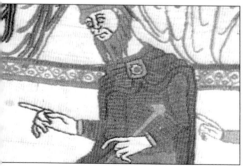

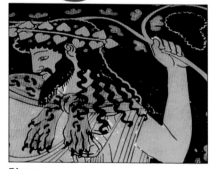

Edward the Confessor
Detail from the Bayeux Tapestry
France, late 11th century. Embroidered textiles.

Dionysus
Detail from an amphora
Greece, c. 500 BC. Paint on clay.

Man Leaning over a Balustrade
Raphael (Raffaello Santi) (1483-1520)
Italy, c. 1515. Pen and ink

**The Bones of
the Hands**
Detail from *De
Humani Corporis
Fabrica*. Jan van Calcar
(*fl.* 16th century). Germany,
1554-5. Wood engraving

**Hand "In
Benediction" and
Two Arms
"Counter-embowed
and Interlaced"**
Heraldic devices used
on shields. England,
12th century. Print

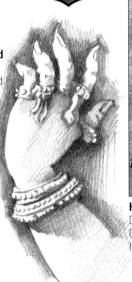

Siva Nataraj
Detail from the
Halebid temple
India, c. 1120-65
Carved stone

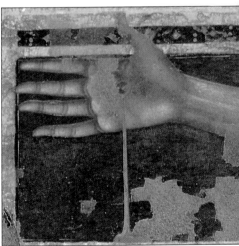

Hand of the Crucified Christ
Detail from the *San Croce Crucifix*
Cimabue (Cenni di Pepi) (c. 1240-after 1302)
Italy, 1280s. Tempera on wood

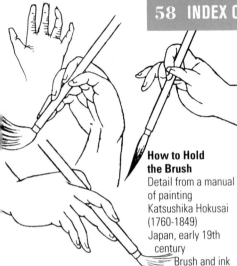

**How to Hold
the Brush**
Detail from a manual
of painting
Katsushika Hokusai
(1760-1849)
Japan, early 19th
century
Brush and ink

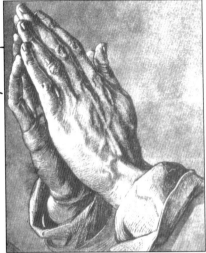

Praying Hands
Albrecht Dürer
(1471-1528)
Germany, c.1505
Crayon

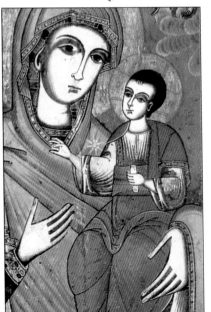

**Chief's Stool
with Caryatids**
"Master of Buli"
(*fl.* 19th century)
Congo, 19th century
Carved wood

**The Virgin
Hodegetria with
Prophets**
Bulgaria, 17th century
Wall painting

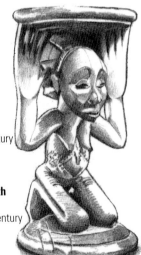

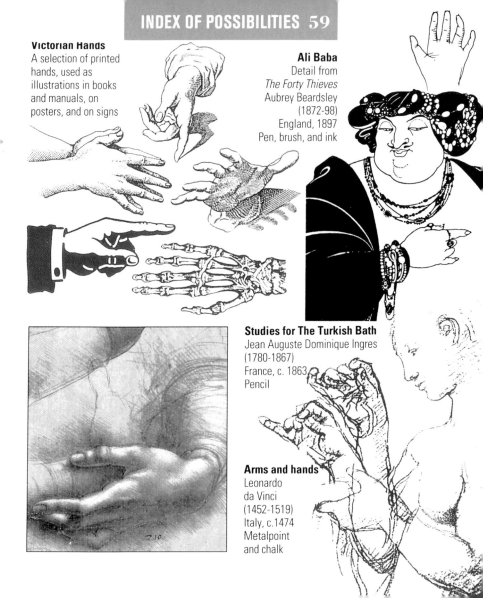

Victorian Hands
A selection of printed hands, used as illustrations in books and manuals, on posters, and on signs

Ali Baba
Detail from
The Forty Thieves
Aubrey Beardsley
(1872-98)
England, 1897
Pen, brush, and ink

Studies for The Turkish Bath
Jean Auguste Dominique Ingres
(1780-1867)
France, c. 1863
Pencil

Arms and hands
Leonardo
da Vinci
(1452-1519)
Italy, c.1474
Metalpoint
and chalk

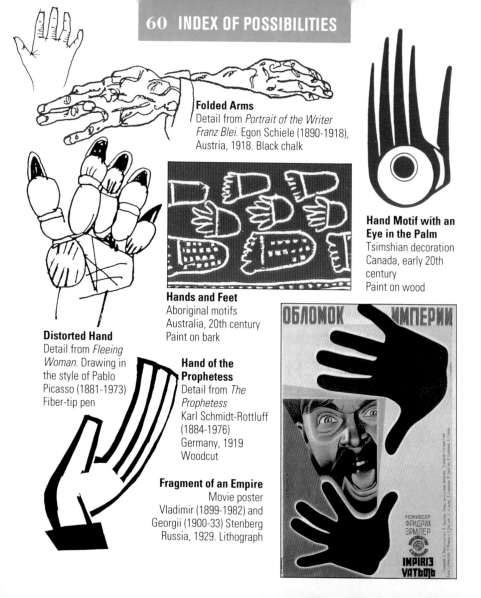

Folded Arms
Detail from *Portrait of the Writer Franz Blei.* Egon Schiele (1890-1918), Austria, 1918. Black chalk

Hand Motif with an Eye in the Palm
Tsimshian decoration
Canada, early 20th century
Paint on wood

Hands and Feet
Aboriginal motifs
Australia, 20th century
Paint on bark

Distorted Hand
Detail from *Fleeing Woman.* Drawing in the style of Pablo Picasso (1881-1973)
Fiber-tip pen

Hand of the Prophetess
Detail from *The Prophetess*
Karl Schmidt-Rottluff (1884-1976)
Germany, 1919
Woodcut

Fragment of an Empire
Movie poster
Vladimir (1899-1982) and Georgii (1900-33) Stenberg
Russia, 1929. Lithograph

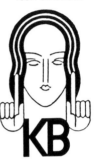

Mickey Mouse
Detail.
© Walt Disney
Features . Walt
Disney (1901-66)
USA, since 1929
Animated cartoons
and comics

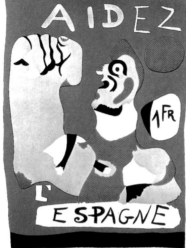

Aidez l'Espagne
Poster. Joan Miró
(1893-1983). Spain,
1937. Silkscreen

KB Logo
England, 1929. Print

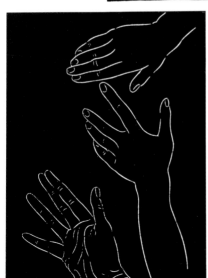

Three Hands
Detail from *Twenty-five Nudes*
Eric Gill (1882-1940)
England, 1937
Woodcut

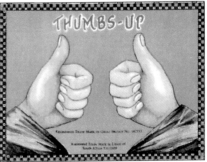

Thumbs-up
Cotton label
England, 1920s
Colored print

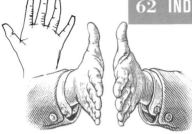

Pair of Hands
Britain, 1990s
Wood engraving

Hand Design
Italy, 1992
Gouache

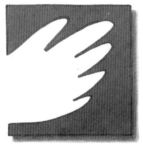

Self-portrait
Detail. David Alfaro Siqueiros
(b. 1896). Mexico, 1943.
Pyroxylin on celotex

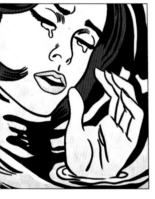

Drowning Girl
Roy Lichtenstein
(b. 1923). USA, 1963
Oil and magma on
canvas

**Hands as a
Young Man**
George Underwood
(b. 1947). England,
1979. Oil on canvas

The Mediterranean
Jean Cocteau
(1891-1963)
France, c.1950
Pen and ink

Eye hand
England, 1990s
Pen and ink

Face and hands
Fernand Léger (1881-1955)
France, 1952. Brush and ink

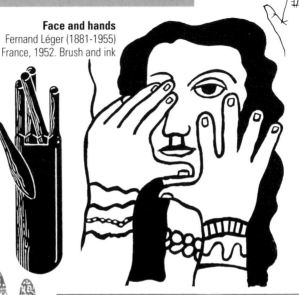

Tree hand
George Hardie
(*fl.* 20th century). England,
1990s. Woodcut

Palm designs
India, 20th century
Henna vegetable dye

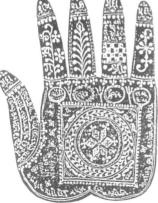

The Man with the Golden Arm
Movie poster. Saul Bass (b. 1920)
USA, 1954. Mixed media

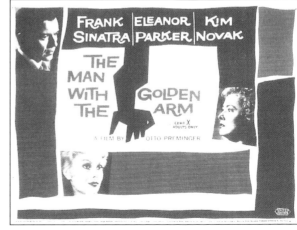

FRANK SINATRA ELEANOR PARKER KIM NOVAK

THE MAN WITH THE GOLDEN ARM

CERT X ADULTS ONLY

A FILM BY OTTO PREMINGER

CONTRIBUTORS AND CONSULTANTS

Contributing artists

Victor G. Ambrus was born in Budapest, Hungary, where he studied at the Hungarian Academy of Fine Art before continuing his studies at the Royal College of Art in London. Since then, he has worked as a freelance illustrator for over 250 books, and has twice won the Kate Greenaway award for book illustration. He is a Fellow of the Royal Society of Arts and the Royal Society of Engravers.

Robin Harris qualified in Industrial Design at the Central School of Art in London, and was awarded a Royal Society of Arts travel bursary. He is a professional illustrator and designer whose work has appeared in many books and manuals; he reckons to have drawn over 3000 pairs of hands in this time. He is a Fellow of the Royal Society of Arts, and a contributing artist to *Ways of Drawing Eyes* in this series.

Educational consultant

Carolynn Cooke gained a degree in Graphic Design from Canterbury College of Art and a Postgraduate Certificate of Education from Leicester University. She has been teaching art for over twenty years, and is currently Head of Art and Design at Impington Village College, near Cambridge, England.

SOURCES/BIBLIOGRAPHY

In addition to the original artwork shown in this book, many books, journals, printed sources, galleries, and collections have been consulted in the preparation of this work. The following will be found to make useful and pleasurable reading in connection with the history and development of the art of drawing hands:

African Art, R. Wassing, Alpine Fine Arts, 1968
Arbanassi: Iconostases and Religious Easel Art, S. Bossilkov, Svyat, 1989
An Atlas of Anatomy for Artists, F. Schider, Dover, 1957
The Bayeux Tapestry, King Penguin, 1944
Beardsley, D. Pearson, Courtier, 1966
British Trademarks of the 1920s and 1930s, J. Mendenhall, Angus & Robertson, 1989
Classical Greece, C. Bowra, Time-Life, 1966
The Complete Book of Drawing, J. Parramón, Phaidon, 1993
The Complete Encyclopedia of Illustration, J. Heck, Merehurst Press, 1990
A Complete Guide to Heraldry, Nelson, 1951
Le Crucifix de Cimabue, U. Baldini and O. Casazza, Musée de Louvre, 1982
Design Motifs of Ancient Mexico, J. Enasco, Dover, 1953
Design Since 1945, P. Dormer, Thames & Hudson, 1993
The Diary of Raphael, C. Border, Macmillan, 1962
Drawings, J. Cocteau, Dover, 1981
Egon Schiele, F. Whitford, Thames & Hudson, 1981
Egyptian Art, C. Aldred, Thames & Hudson, 1980
The Encyclopedia of Comic Books, R. Goulart, Time as Art, 1990
The Encylopedia of Illustration, G. Quinn, Studio Editions, 1990
F. Léger, G. Néret, Cromwell Editions London, 1993
Hands: A Pictorial Archive, J. Harter, Dover, 1985
In Praise of Hoysala Art, R. del Bonta, Marg, 1980
Leonardo da Vinci, South Bank Center, 1989
Mexican Art, J. Fernández, Hamlyn, 1965
Picasso's Picassos, D. Duncan, Macmillan, 1961
Roy Lichtenstein, J. Hendrickson, Benedikt Taschen, 1992
The Twentieth-century Poster, D. Ades, Abbeville Press, 1984

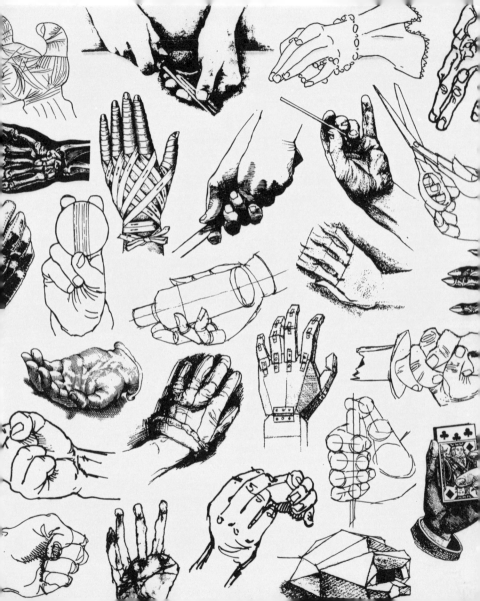